FOR DOG'S SAKE!

JOHN DONEGAN

Souvenir Press

By the same author
DOG ALMIGHTY!
DOG HELP US!

First published 1990 by Souvenir Press Ltd,
43 Great Russell Street, London WC1B 3PA
and simultaneously in Canada

ISBN 0 285 63004 0

Photoset, printed and bound in Great Britain by
Redwood Press Limited,
Melksham, Wiltshire

A few of the cartoons in this book
have previously appeared in *Punch*
and are reproduced by kind permission
of the proprietors, Punch Publications Ltd.

'You're not making things any easier for me, Monty.'

'It's The Wild again.'

'. . . and this time, don't feign a limp, don't chew his stethoscope, and don't call him "Doc".'

'. . . and don't fall for all that "Best Friend" stuff. We're just another investment.'

'Nothing to it. Just keep showing them how, then, one day, *you* throw it.'

'If the Good Lord had meant me to run He would have given me a tracksuit.'

'I've never called anyone "Sir" and I don't intend to start now.'

'Never mind "Pourquoi?" Just fetch it.'

'They're identical, except that one says "Potato" and the other says "Potahto".'

'Well, can I have the bit you're *not* reading?'

'You're as near to it as I am — you fill 'em up.'

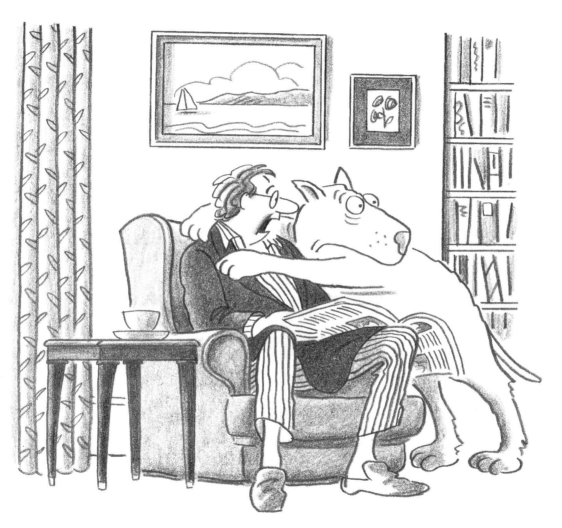

'For pity's sake, Max, it's only the postman!'

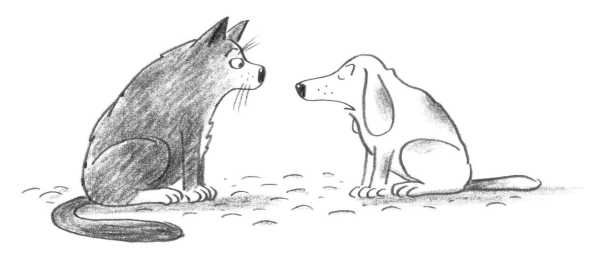

'You're an eco-system and I'm an eco-system. Anything that has fleas
is an eco-system.'

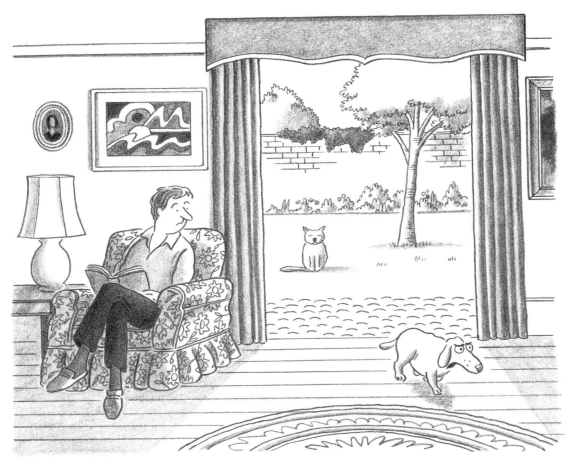

'White cat speak with forked tongue.'

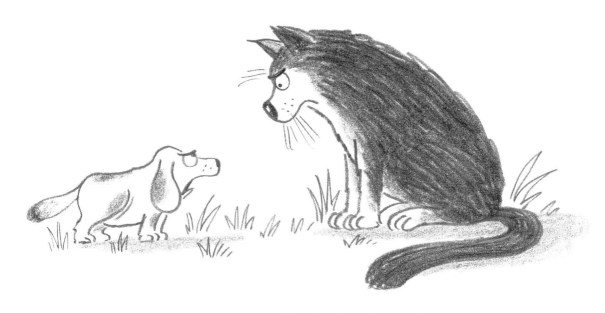

'I warn you — I don't take prisoners.'

'It certainly *is* my business! I happen to be an ornithologist.'

'For once I agree with you — it's an improvement.'

'Oh, I *do* beg your pardon. I didn't know it was leg-licking time.'

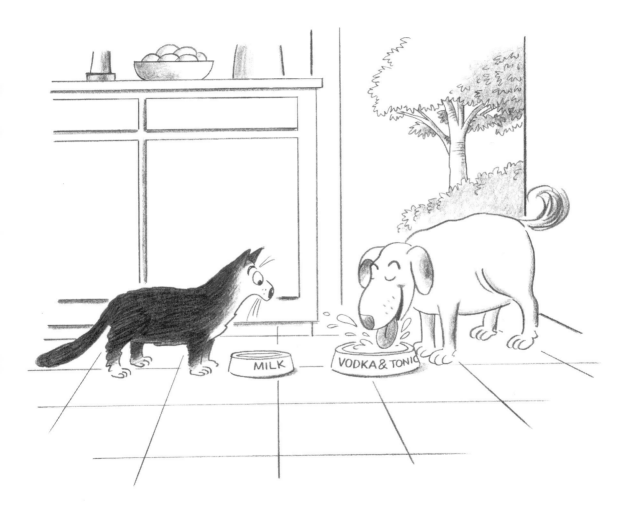

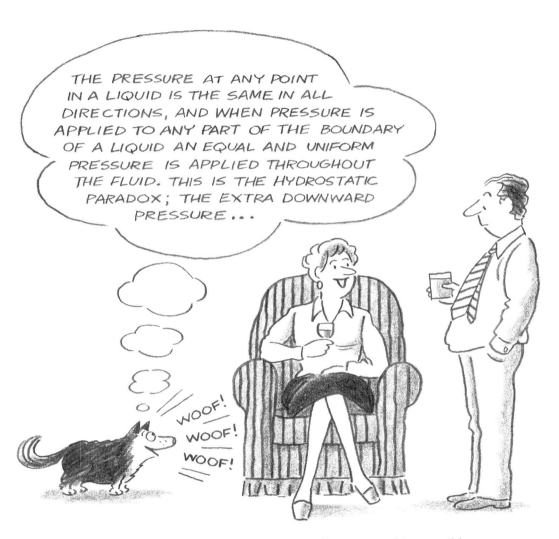

'Listen to him, dear. He's trying to tell you something terribly important.'

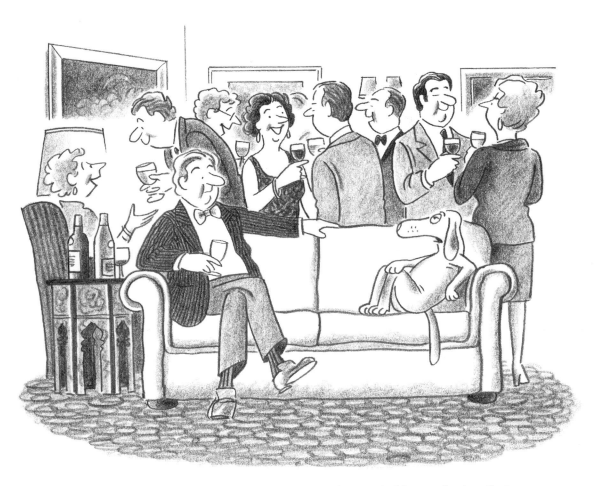

'Eventually, of course, one was forced to the inevitable conclusion that,
for all practical purposes, barking is a dead language.'

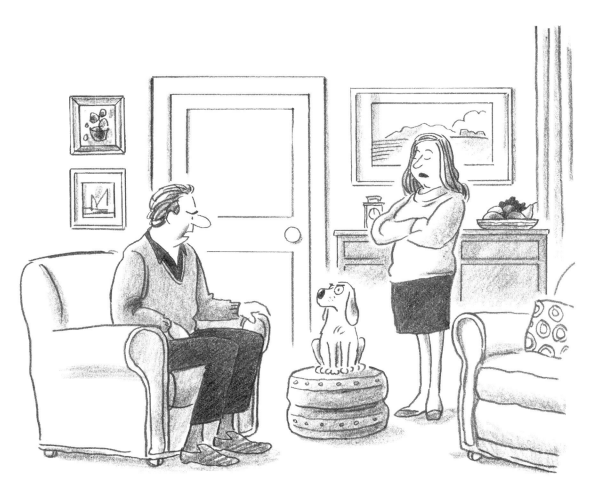

'The accused will confine his answers to "Yes" or "No".'

'Look, if it makes you feel any better, *I'll* forget *your* birthday.'

'It's high time we had his claws clipped. I can't take much more of that
tap-dancing.'

'I think you should have a word with him, Douglas. He wants to have his ears pierced.'

'Any chance of a drink while I'm waiting?'

'Well, *we* like it with garlic and herbs'

'Closer, please. Just a little closer.'

'Sorry to interrupt, but who the hell *is* that?'

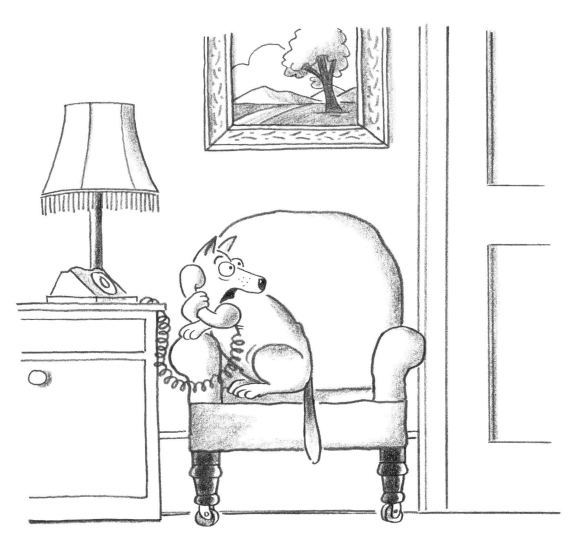

'How many times do I have to tell you, Trixie? Don't ring me at home!'

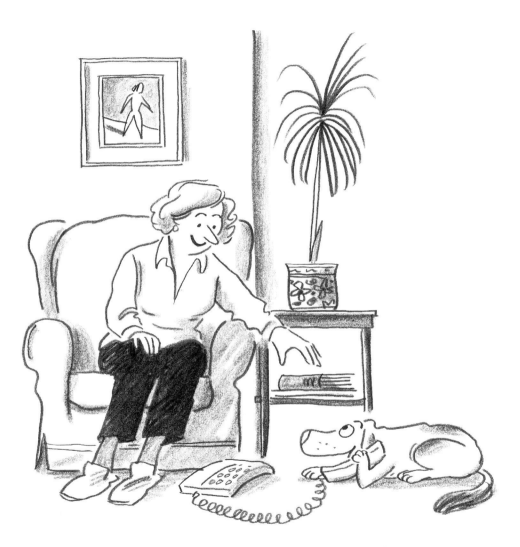

'Hold on: you-know-who wants to say "Hello".'

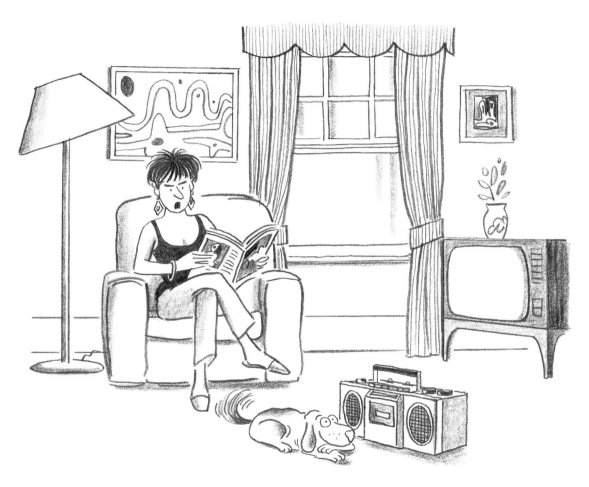

'Turn that down, or take it up to your room!'

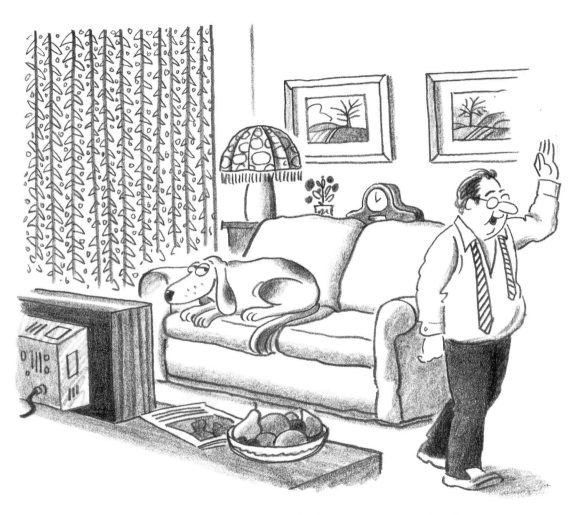

'Goodnight, Gus. Thanks for letting me stay up late.'

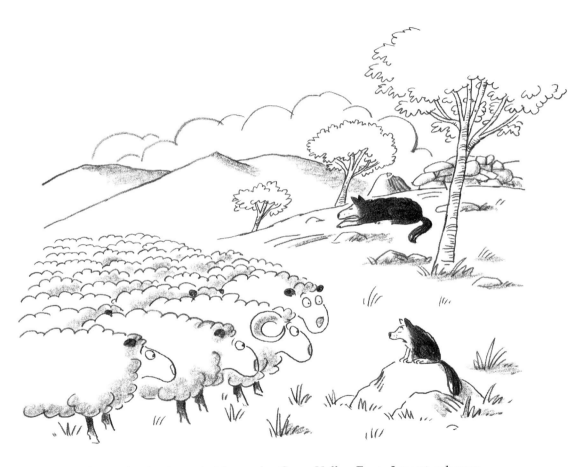

'By the authority invested in me by Cwm Valley Farm I must ask you
to proceed down to the far end of the field in an orderly manner, there
to disperse and go about your business pending further instructions. In
short — move it.'

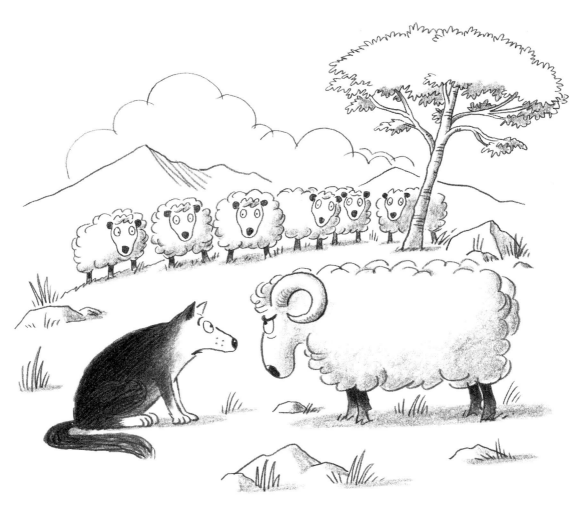

'Don't push your luck, stupid. One taste of blood and I'll be sick.'

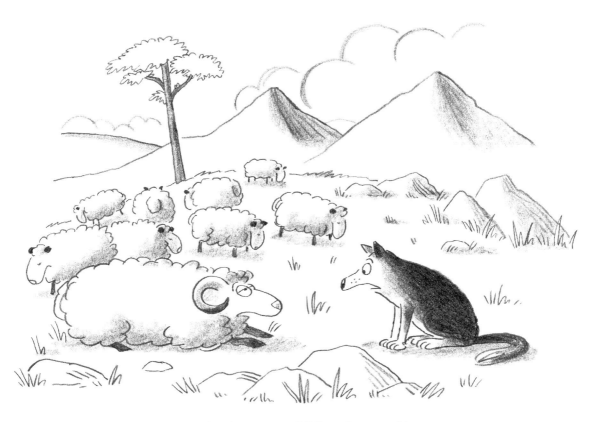

'*You're* typecast? What about me?'

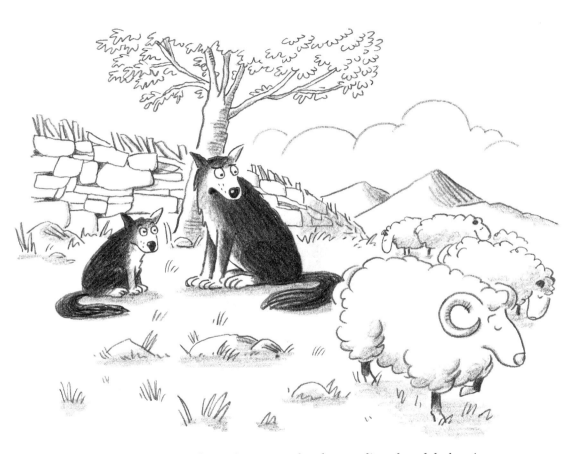

'That's what I hate about pure-bred rams: limp handshakes.'

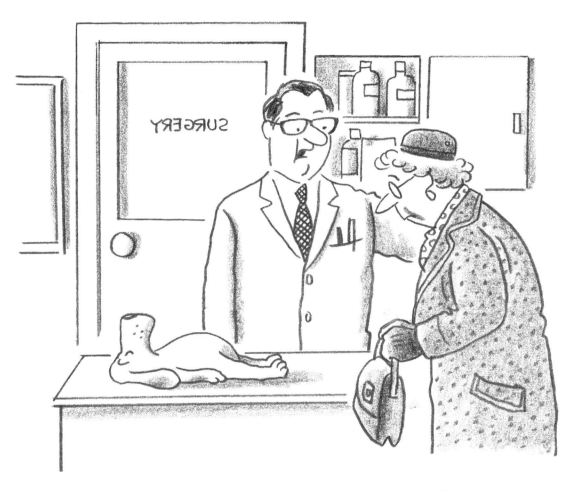

'It may comfort you to know, Mrs Bertram, that he took a hell of a lot
of worms with him.'